PEACE

100 IDEAS

CDA PRESS

SAN FRANCISCO

PEACE 100 IDEAS

BY JOSHUA C. CHEN & DR. DAVID KRIEGER

DESIGN BY CHEN DESIGN ASSOCIATES

INTRODUCTION

"How lovely are the messengers who announce the good news of peace. To all the nations is gone forth the sounds of their words, their glad tidings bring." — Felix Mendelssohn (from *St. Paul's Oratorio*, 1873)

A classical anthem performed by my church choir recently prodded me to further consider our role as visual communicators, and in particular, how we shape our surrounding environment with the ideas we put forth through graphic design. As designers, we create solutions for clients that are designed to communicate a core idea or set of ideas to the greatest number of people possible. The intent of these solutions is to form or change a perception, to engage an audience, and to inspire a desired action. Why not take this process and apply it towards delivering a positive message that will inspire people to act for the good of the whole?

About a year ago, we at Chen Design Associates decided to develop a project that would showcase creativity and the potential of high-quality design without becoming yet another

self-congratulatory design firm promotional. The project would celebrate design in the context of communicating a much larger, much more important idea. During this time, a list authored by Dr. David Krieger, president of the Nuclear Age Peace Foundation, came to our attention. *100 Ways to Promote a More Peaceful World* inspired us with its redefinition of acts of peace as simple, practical deeds that could be carried out in our everyday lives. The list was accompanied by a call to "take this list, make it your own, and contribute to the furthering of peace in the world." No additional encouragement was necessary.

Most people are familiar with the concept of peace, as well as with the imagery and stereotypes connected with it — the peace symbol, tie-dye, hippies, radical protesters, and Volkswagen buses. In many cases, particularly in the United States, peace has become a marketable commodity focused on a past culture that has little to do with achieving actual solutions for our current world. In reality, peace is relief from war. Peace is clean drinking water and food on the table. Peace is being aware of government actions. It is putting others first. It is the support and love of a family. The more we thought about peace, the more its meaning changed from a stereotype to an achievable, and essential, way of life. With Dr. Krieger's list as our foundation, we began to build on and adapt the ideas to create a project that would represent the many facets of peace, dispel preconceptions and stereotypes, and challenge people to rethink their own definition of the word. What better way to bring these ideas to life but to juxtapose them against thought-provoking illustrations?

Peace: 100 Ideas emerged out of a desire to be responsible with the messages we deliver through the medium of design, and to utilize our design skills to generate support for a higher cause. Ten percent of proceeds from sales of this book go towards wagingpeace.org's ongoing mission of achieving a peaceful way of living in our modern world. Additional proceeds will be reinvested into the project to ensure that its message continues to be heard.

In addition, care has been taken to ensure that this product has been produced with respect to our environmental resources. As mentioned earlier and as exemplified in this book, an act of peace can take many forms. To walk gently on this earth and care for its well-being, to sustain life and the continuation of interconnected living systems are all acts of peace with consequences that will last for generations to come. This includes printing with inks that are not harmful to the environment, on paper that is made up of 100% post-consumer waste. No new trees were used in the production of this book.

There are many ways to get involved in working towards a peaceful world. This book is a starting point — a catalyst that we hope will inspire others to think of their own creative solutions for peace. Share those new ideas and encourage others to do the same. Join an organization committed to achieving peace such as a community-based group, a program sponsored by a religious organization, or an inner city outreach service. Just as the meaning

of the word "peace" can be interpreted in many ways, so can the positive contributions of these organizations translate into "peace." While we do not provide a resource list in this book, the companion web site has a section dedicated to peace related resources, updates on the evolution of the *Peace: 100 Ideas* project, and opportunities to voice opinions and ideas regarding peace. Visit the site at www.peace100ideas.com

Peace: 100 Ideas is made possible through the dedication and collaborative effort of many people who believe in the message of peace. In developing this project we have had many opportunities to examine how we act on behalf of peace in our own lives and where there is room for improvement. We have gained a sense of the bigger picture as well as the value of those people and acts closest to home. It has motivated us to seek ways of working for peace in addition to developing some of the ideas that have become personal guiding lights. We hope that you learn from and are inspired by this book, and that you take its meaning to heart. Most of all, in the words that first opened the door to this project, we ask that you "take this list, make it your own," and become a vital messenger in sharing the message of peace.

Joshua C. Chen
Principal & Creative Director
Chen Design Associates

FOREWORD

There is a Roman dictum, "If you want peace, prepare for war." This has been diligently followed for over 2,000 years. It has always resulted in more war. We need a new dictum: "If you want peace, prepare for peace." This is the challenge of our time.

We live in an amazingly beautiful world, and each of us is a miracle. All the things that we take for granted are causes for wonder: that we can see this beautiful earth, its trees and streams and flowers; that we can hear songs, that we have voices to speak and sing; that we can communicate with each other; that we can form relationships and can love and cherish each other; that we can walk and breathe and do all the incredible

things we take for granted. If we can learn to appreciate how miraculous we truly are, perhaps we can also appreciate that each of us is equally a miracle. How then can one wish to injure or kill another? The gift of life must be rooted in appreciation, which will give rise to compassion and empathy.

We all have a choice about what we do with our lives. We can devote our lives to accumulation of material things, which is culturally acceptable, or we can set our sights on fulfilling more compassionate goals aimed at building a peaceful world.

The Earth Charter, a wonderful document that was created with input from people all over the world, begins with these words: "We stand at a critical moment in Earth's history, a time when humanity must choose its future." But humanity will not choose by a vote. The choice will be made by the individual choices of each of us. Each choice matters.

In 1955, Albert Einstein, the great scientist and humanitarian, and Bertrand Russell, a leading 20th century philosopher and social critic, issued a manifesto in which they concluded: "There lies before us, if we choose, continual progress in happiness, knowledge and wisdom.

Shall we, instead, choose death, because we cannot forget our quarrels? We appeal as human beings to human beings: Remember your humanity, and forget the rest. If you can do so, the way lies open to a new Paradise; if you cannot, there lies before you the risk of universal death."

The two most powerful images that emerged from the 20th century were the mushroom cloud from a nuclear explosion and the view of Earth looking back from outer space. The mushroom cloud represents universal destruction, while the view of Earth from outer space represents the unique and solitary beauty of our planet, the only planet we know of that harbors life, in a vast, dark universe. These images represent polar opposite possibilities for humanity's future. Which will we choose?

We need to become personally involved in the issues of our time, and find our own ways to work for a peaceful future. Among the important ways in which we can engage are by speaking out and making our presence felt for a peaceful world. That means opposing policies of violence and war. It means standing up for the human dignity of everyone, everywhere. We must create a world that works for all and we must begin where we are, but our vision and our outreach must be global. We must ask more of our leaders, and we must demand better leaders. We ourselves must become the leaders who will change the world. The most important change has always come from below and from outside the power structure.

My hope for you is that you will choose peace in all of its dimensions.

I believe that the place to begin is by choosing hope. It is your belief that you can make a difference that will allow you to make a difference. Put aside despair, apathy, complacency and ignorance, and simply choose hope. It is the first step on the path to peace.

This book provides 100 ideas for peace. They are about ways of being, thinking, playing, working and connecting with the world. They are ideas that all of us can put into practice. Each idea is embodied in a striking design by Josh Chen and his associates. We hope that the ideas and the designs will inspire you to action. Integrate these ideas into your life. Become more peaceful. Become a teacher of peace by the example you set. Become an artist of peace by the life you live. Stand up and speak out for peace. Make a difference. Our world needs you.

Dr. David Krieger
President, Nuclear Age Peace Foundation
wagingpeace.org

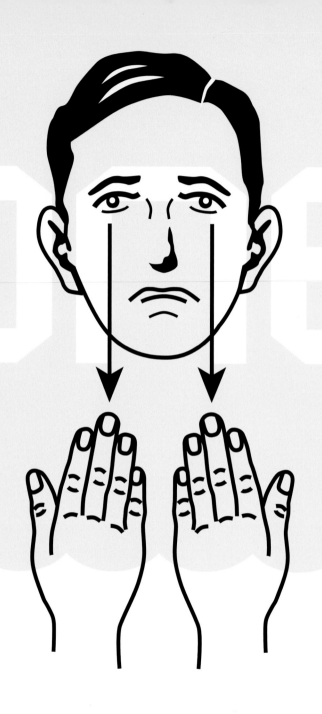

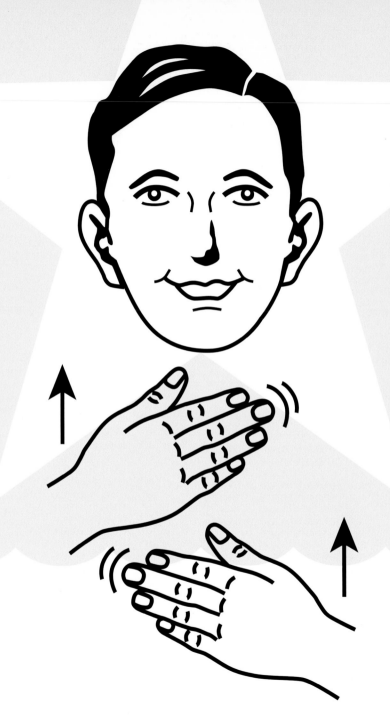

Be generous with your smiles.

2.0

-1.625 0

0 0

:: // COMMI

DAILY ACTS OF KINDNESS // ::

PEACE: 100 IDEAS

number 2 of 100

6.375 2

6.375 0

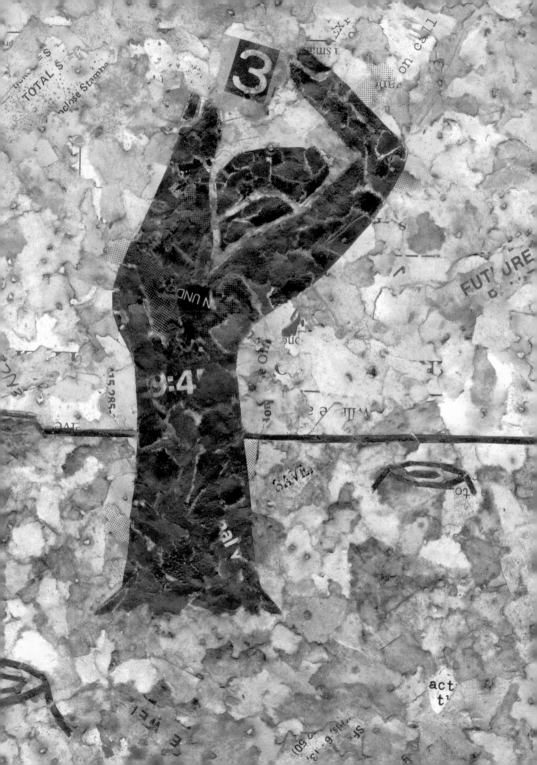

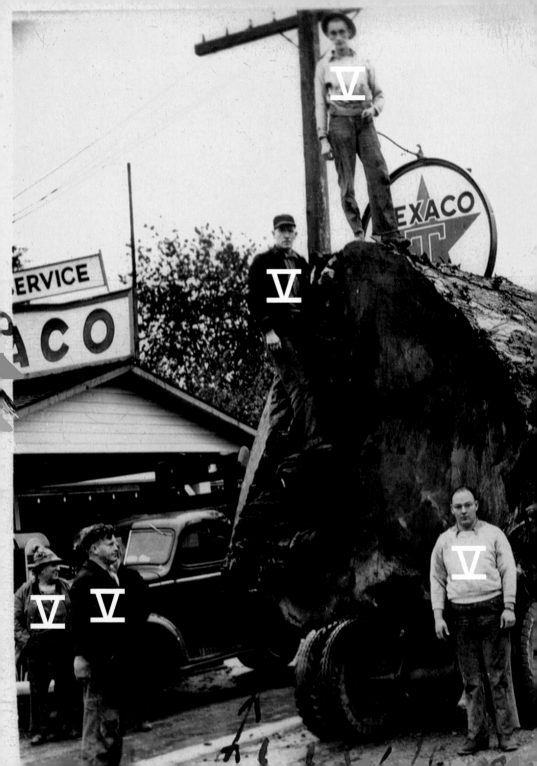

6 **be** SIDE OUT

S

E DON'T

8 LIVE SIMPLY

NINE SKIP A MEAL EACH WEEK

SEND FIVE DOLLARS
TO AN ORGANIZATION
HELPING THE HUNGRY

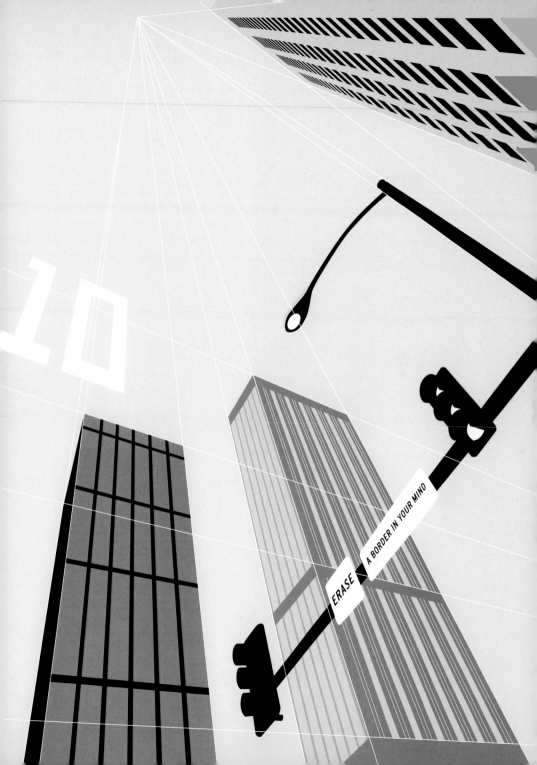

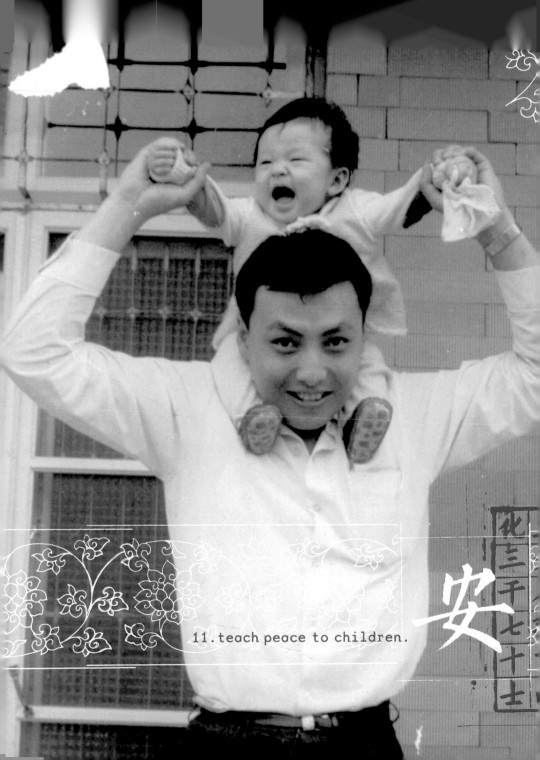

11. teach peace to children.

安

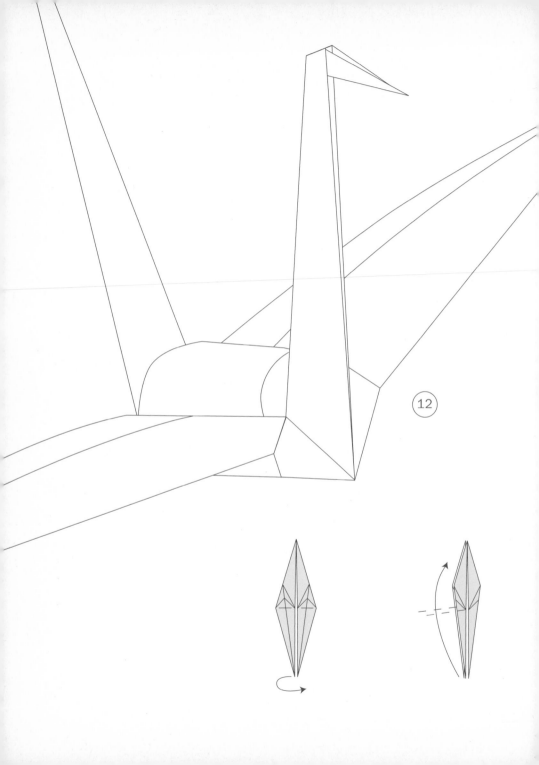

12

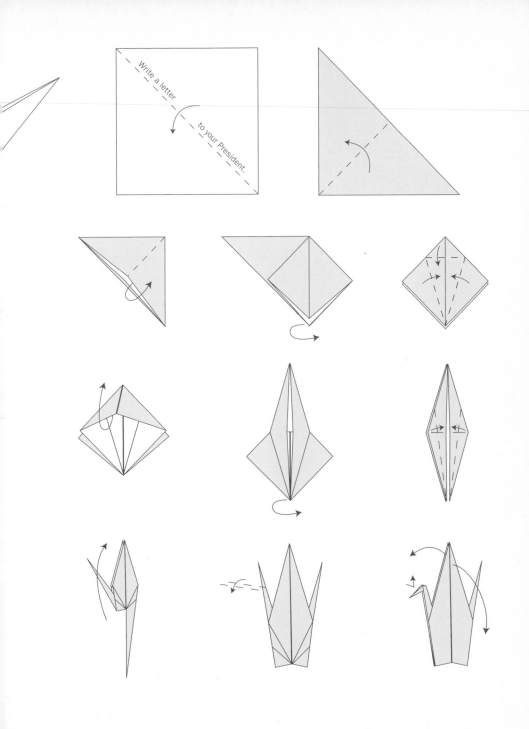

Write a letter to your President.

YOU MUST BE

Study the lives of peace heroes.

YOU WISH TO

WORLD.

THE CHANGE

SEE IN THE

- MOHANDAS K. GHANDI

A

B

THINK ABOUT
CONSEQUENCES

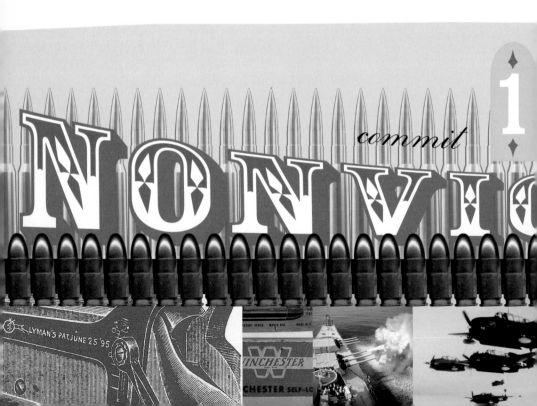

commit **1**

NONVI

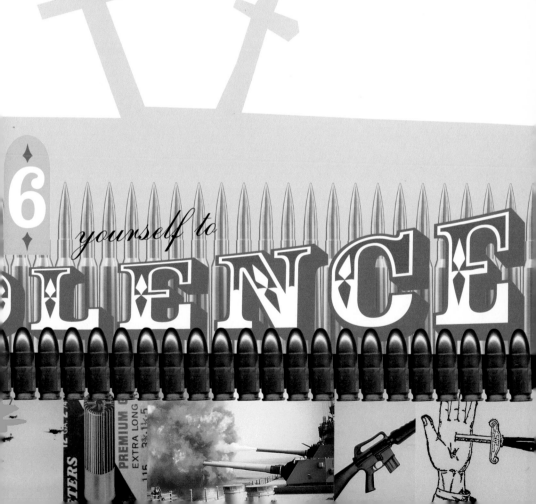

6 *yourself to* OLENCE

17

Support nonviolent solutions to global problems.

18. SPEAK UP FOR A HEALTHY PLANET

18. SPEAK UP FOR A HEALTHY PLANET

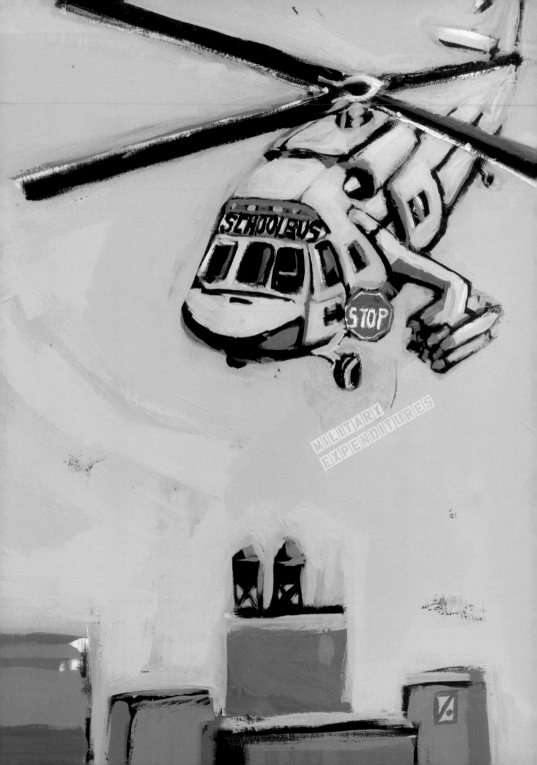

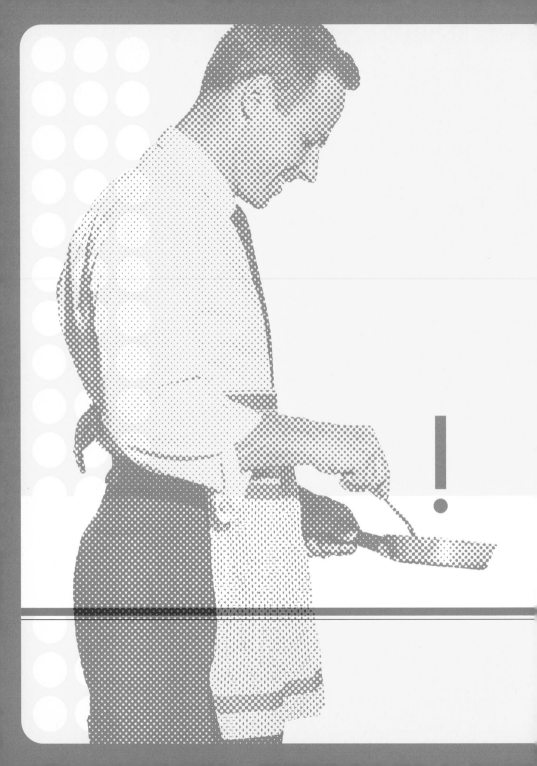

No really, this
time I'll do all
the cooking.

20

Be fair.

I insist.

Gosh, what
an interesting
recipe.

21

Be honest.

Mm mm good.

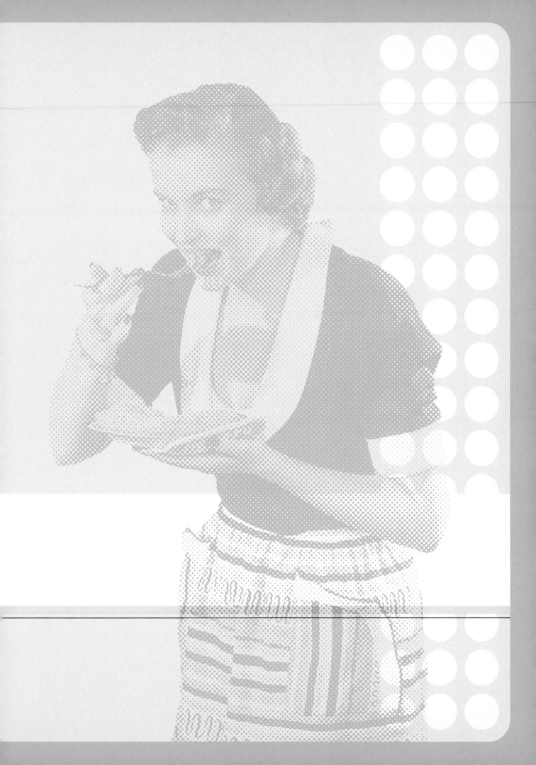

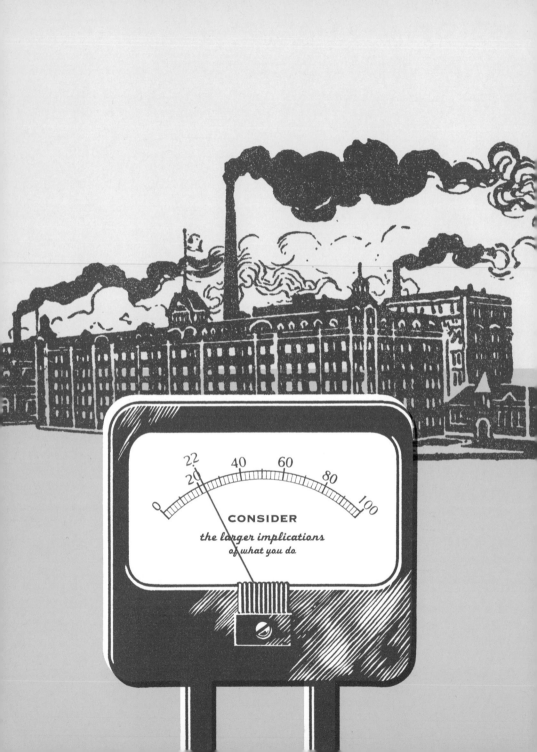

CONSIDER

the larger implications
of what you do

23 children die from hunger every minute

SPoNSo® A NeedY chiLD ABRoaD

RECOGNIZE YOUR UNIQUE POTENTIAL

24

*"woh'
chinese
character
for* **me**

*"woh men'
chinese
characters
for* **we**

THINK

OF

THE

 WE,

NOT

JUST

THE

ME.

我們

BE MO

32

pray

listen to your heart

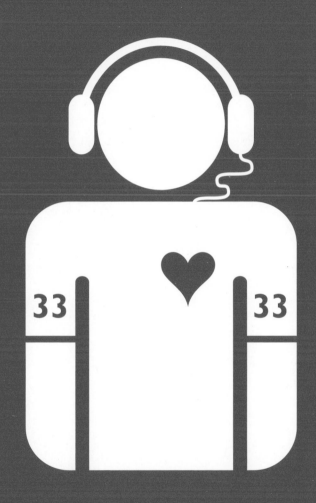

34. HELP THE POOR

THIS PACKAGE CONTAINS THE ITEMS LISTED BELOW

		Food on the table
	R	Comprehensive health care
		Safe, affordable housing

ADMINISTER WITH CARE.

$	Fair wages
	Quality education
	Respect

35

36

Support the cause

of women

without power.

COMMEMORATE
THE INTERNATIONAL DAY OF
PEACE

September 21

39

Advocate universal health care

40.
STAND UP FOR JUSTICE

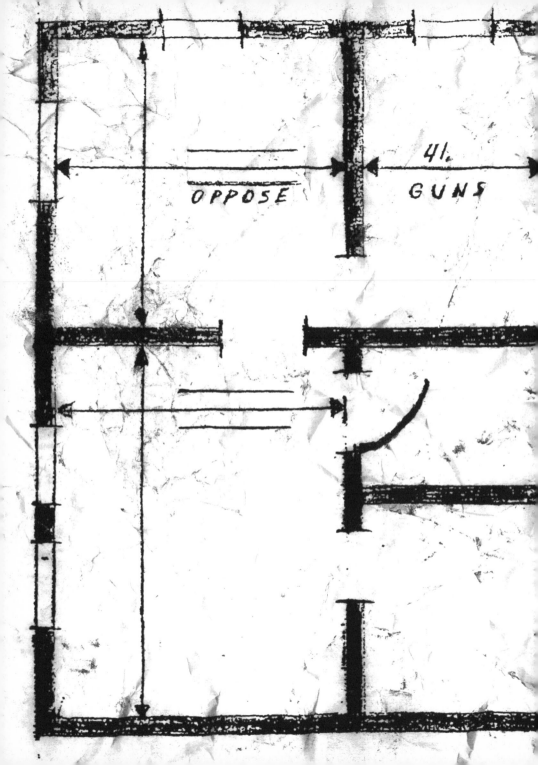

IN THE HOME

CAUTION

USE ONLY UNDER CLOSE ADULT SUPERVISION.
FOR OUTDOOR USE ONLY.
DO NOT PUT IN MOUTH,
THROW ON GROUND.

BE AWARE OF THE RIGHTS OF FUTURE GENERATIONS

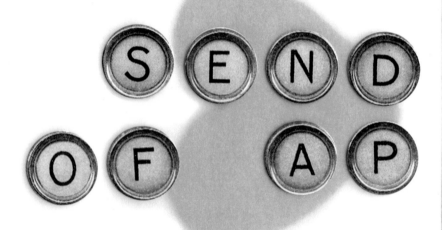

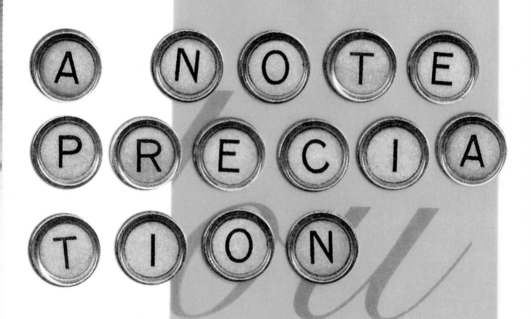

FORTY THREE

43

40-03

A NOTE

PRECIA

TION

Forty-*FOUR!*

Join an

action alert

NETWORK!

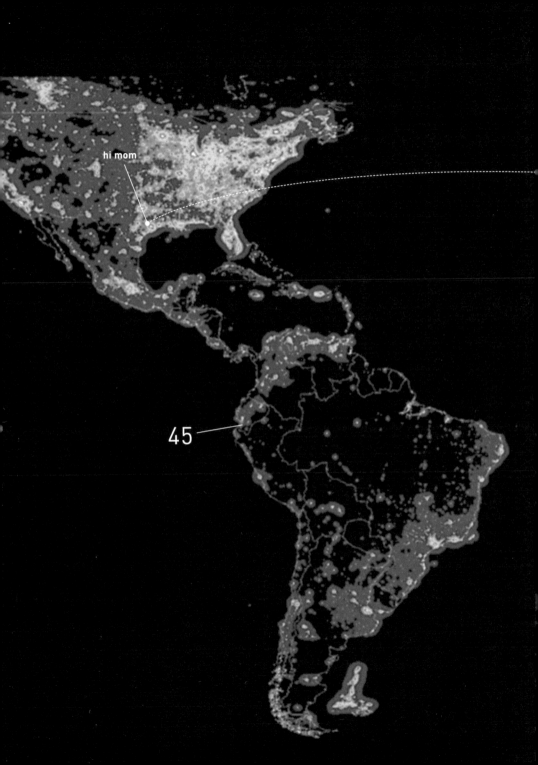

hi mom

45

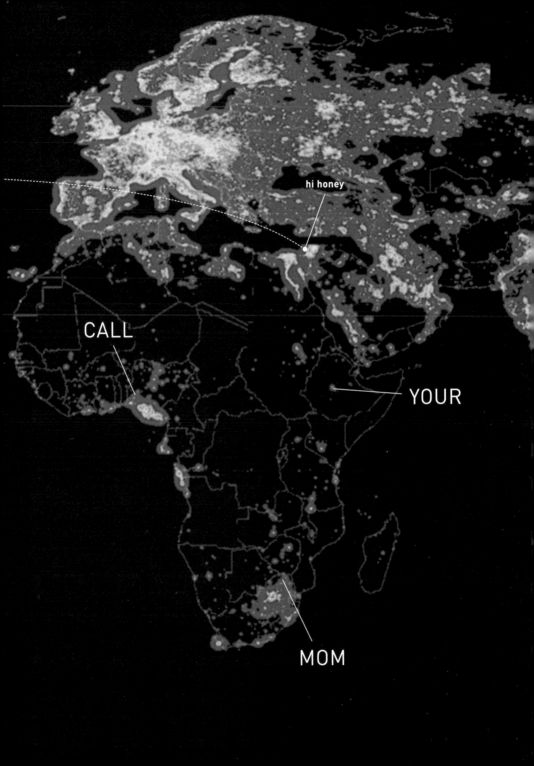

47.
with
child.

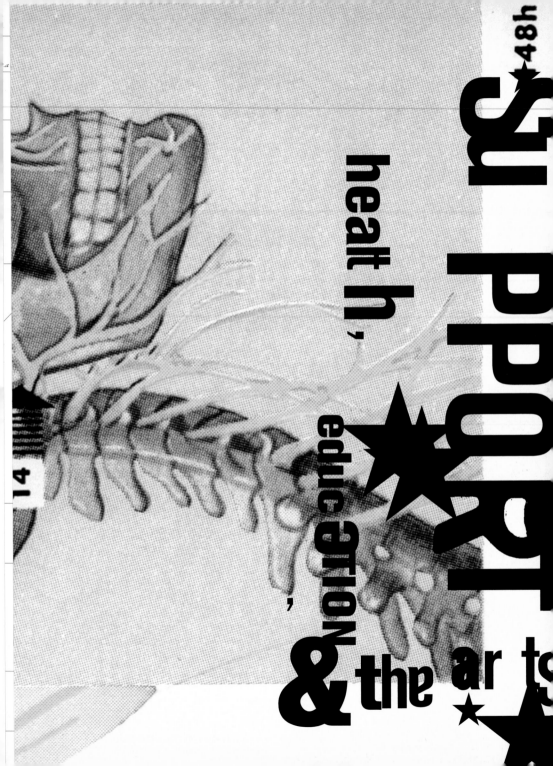

SU PPORT

*484

health,

education,

& the arts

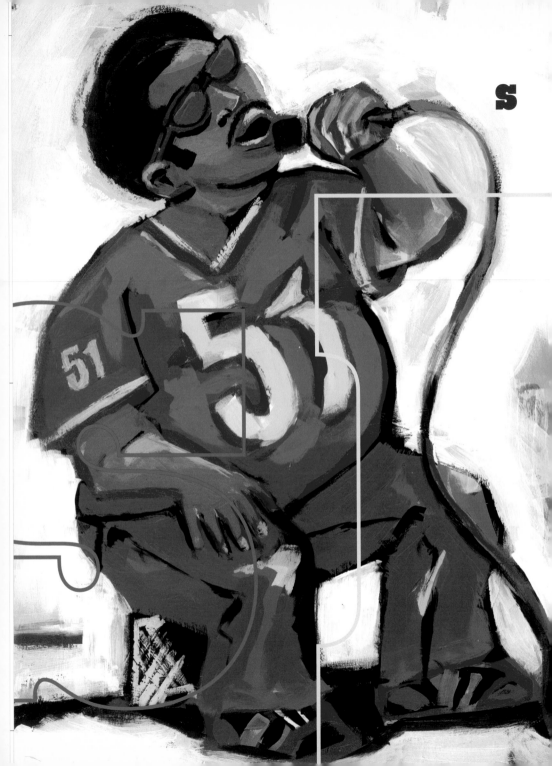

S

52. write a poem.

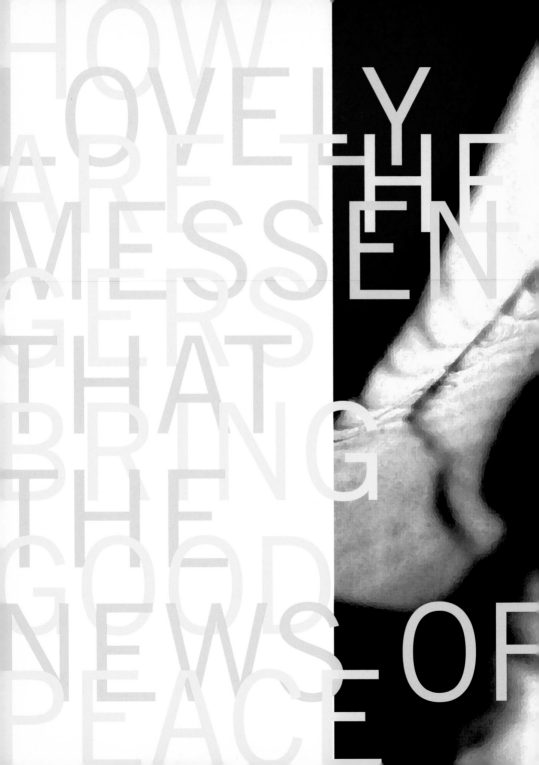

HOW LOVELY ARE THE MESSENGERS THAT BRING THE GOOD NEWS OF PEACE

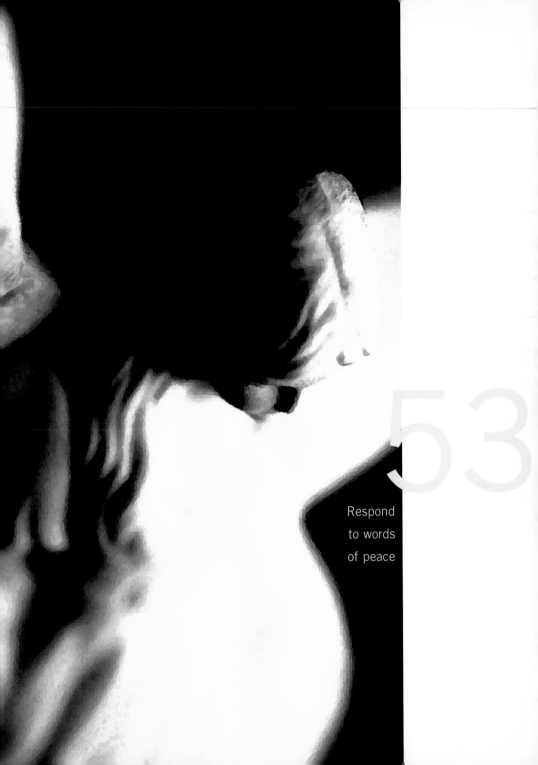

53

Respond
to words
of peace

fifty.

learn

tadi

ntcu

four

abou

fere

ture

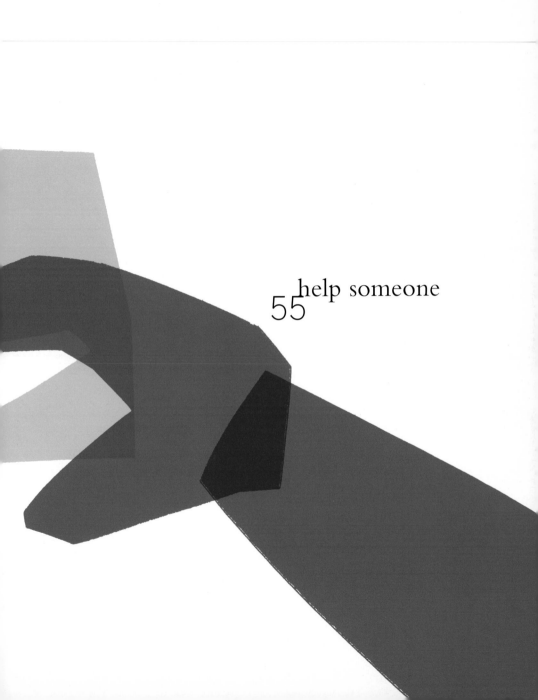

55 help someone

56

ask for forgive ness

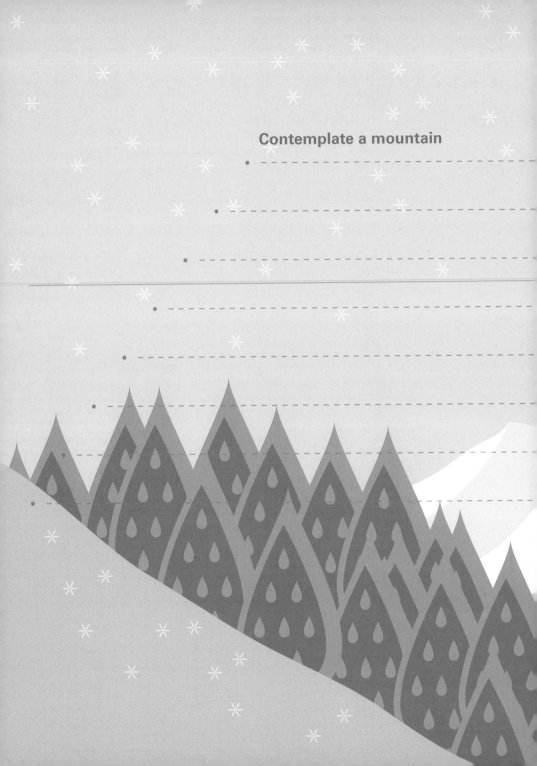

Contemplate a mountain

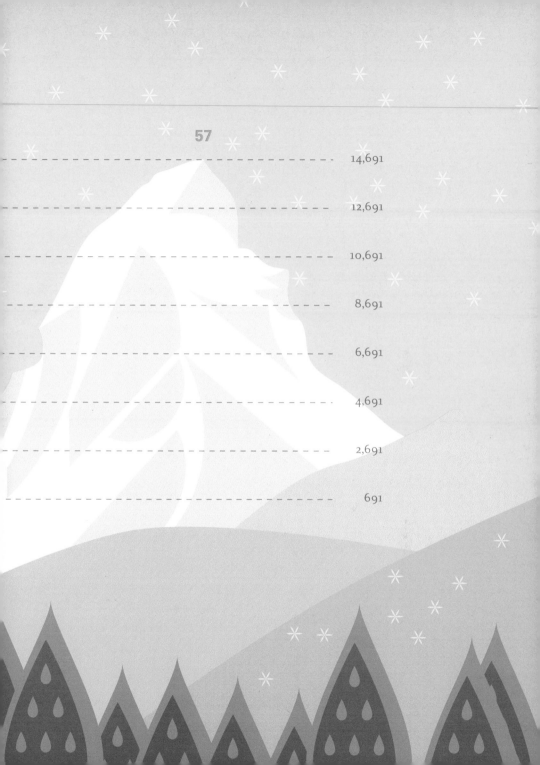

57

- 14,691

- 12,691

- 10,691

- 8,691

- 6,691

- 4,691

- 2,691

- 691

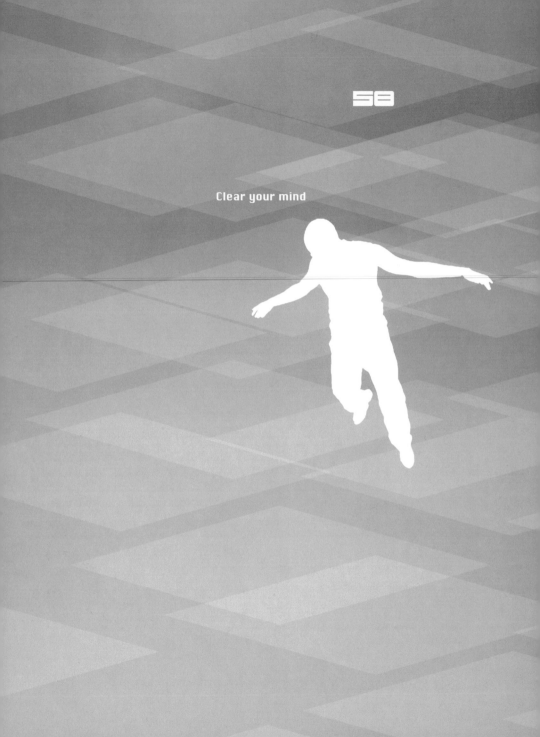

58

Clear your mind

BREATHE DEEPLY

SIXTY SIP TEA

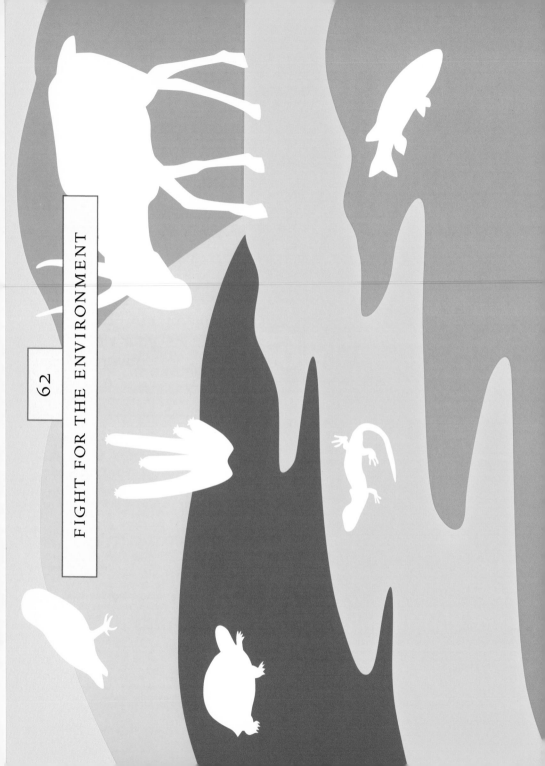

FIGHT FOR THE ENVIRONMENT

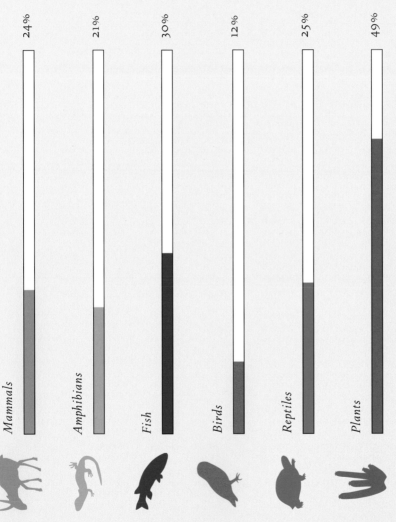

Mammals — 24%

Amphibians — 21%

Fish — 30%

Birds — 12%

Reptiles — 25%

Plants — 49%

% OF TOTAL ASSESSED THREATENED IN 2002 PER THE IUCN RED LIST
OF THREATENED SPECIES

63.
CELEBRATE EARTH DAY

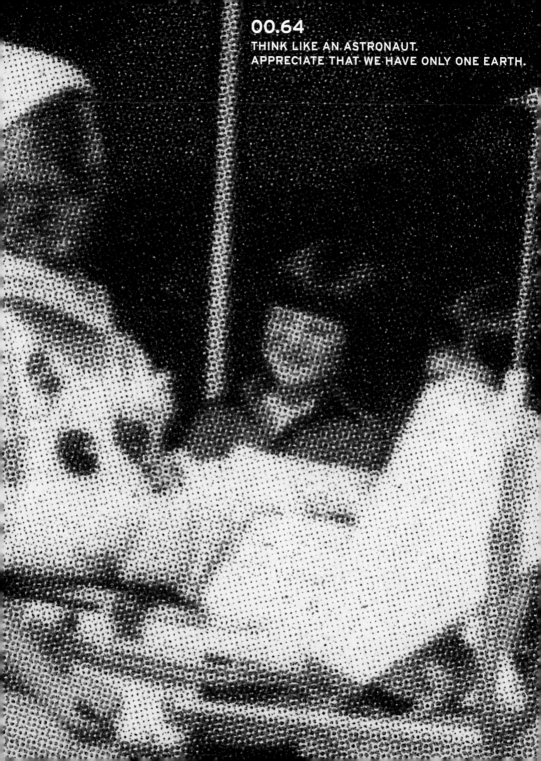

00.64
THINK LIKE AN ASTRONAUT.
APPRECIATE THAT WE HAVE ONLY ONE EARTH.

BE COM

6.

STRUCTIVE 5

66.

Volunteer

time at an

afterschool

program

67

PURCHASE

 PRODUCts that

EARTh's Resources

respECt the ...

WORK IN A GARDEN

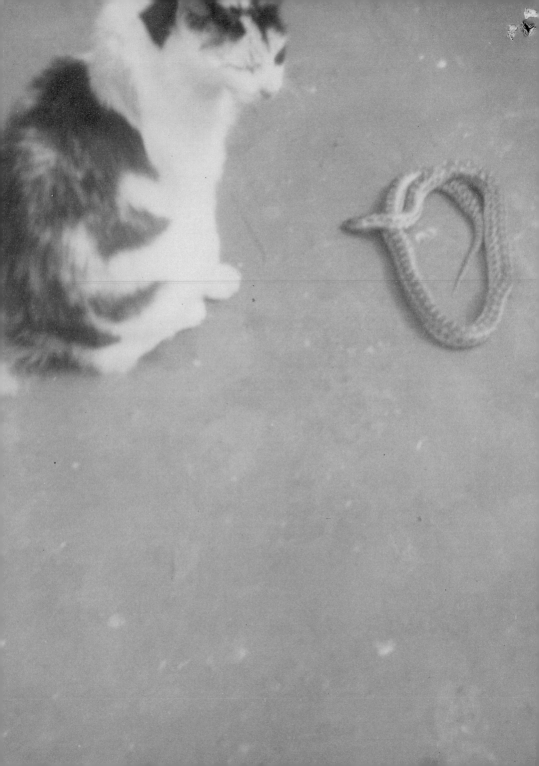

69.
CHANGE A POTENTIAL ENEMY INTO A FRIEND.

70

DON'T TOLERATE PREJUDICE

ONE

comm unity

MANY PERSPECTIVES

share

SEVENTY ONE

Seventy Two

PURCHASE PRODUCTS THAT SUPPORT FAIR LABOR PRACTICES

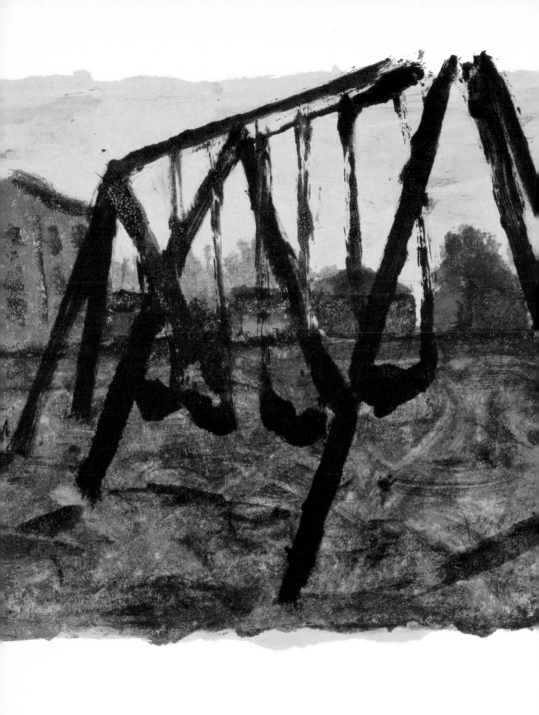

SEVENTY-THREE BE A VOICE FOR THE VOICELESS.

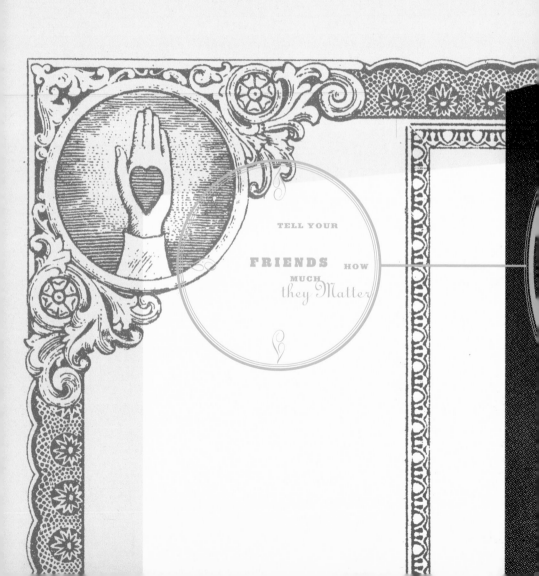

TELL YOUR

FRIENDS HOW

MUCH

they Matter

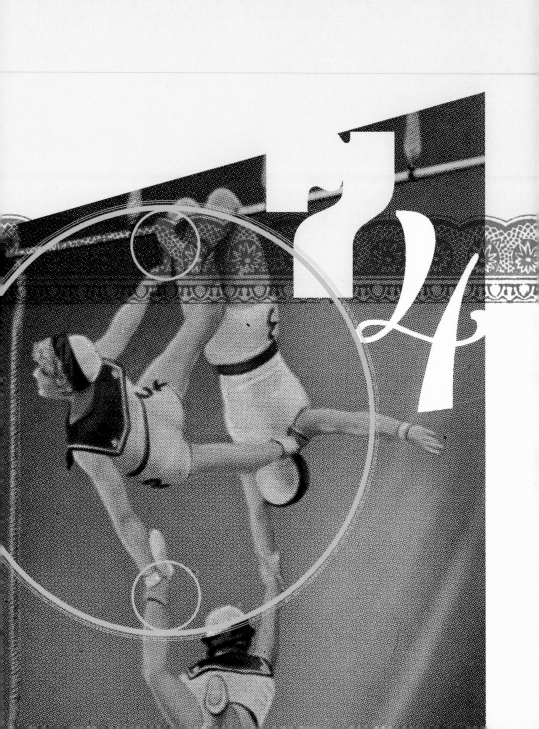

SAY "I LOVE YOU" MORE

76

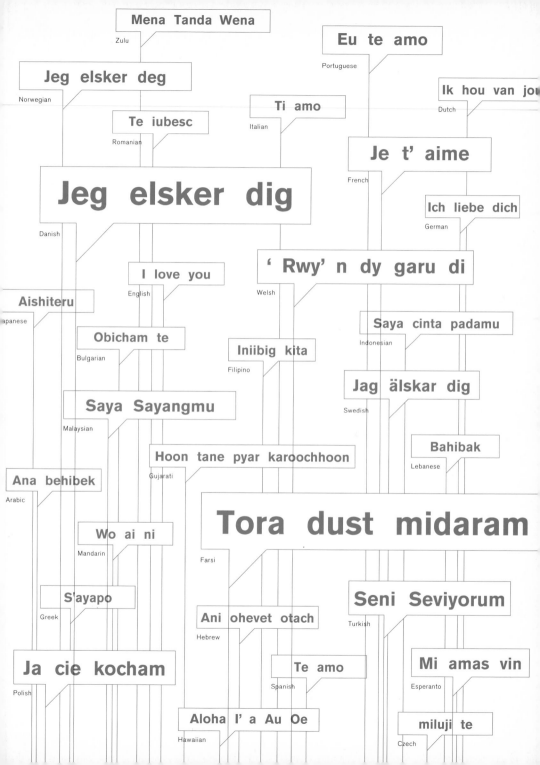

1-734 — PARK & LOCK YOUR CAR

1-791 — PARK & LOCK YOUR CAR

1-291 — PARK & LOCK YOUR CAR

1-682 — PARK & LOCK YOUR CAR

2-334 — PARK & LOCK YOUR CAR

1-392 — PARK & LOCK YOUR CAR

1-936 — PARK & LOCK YOUR CAR

1-451 — PARK & LOCK YOUR CAR

1-305 — PARK & LOCK YOUR CAR

2-001 — PARK & LOCK YOUR CAR

1-399 — PARK & LOCK YOUR CAR

1-992 — PARK & LOCK YOUR CAR

2-015 — PARK & LOCK YOUR CAR

1-211 — PARK & LOCK YOUR CAR

LET — PARK & LOCK YOUR CAR

1-220 — PARK & LOCK YOUR CAR

1-329 — PARK & LOCK YOUR CAR

1-838 — PARK & LOCK YOUR CAR

1-395 — PARK & LOCK YOUR CAR

1-933 — PARK & LOCK YOUR CAR

2-020 — PARK & LOCK YOUR CAR

2-023 — PARK & LOCK YOUR CAR

1-943 — PARK & LOCK YOUR CAR

2-035 — PARK & LOCK YOUR CAR

1-744 — PARK & LOCK YOUR CAR

1-854 — PARK & LOCK YOUR CAR

1-031 — PARK & LOCK YOUR CAR

1-337 — PARK & LOCK YOUR CAR

2-036 — PARK & LOCK YOUR CAR

3-201 — PARK & LOCK YOUR CAR

3-457 — PARK & LOCK YOUR CAR

2-594 — PARK & LOCK YOUR CAR

3-564 — PARK & LOCK YOUR CAR

3-100 — PARK & LOCK YOUR CAR

2-739 — PARK & LOCK YOUR CAR

1-047 — PARK & LOCK YOUR CAR

3-653 — PARK & LOCK YOUR CAR

1-054 — PARK & LOCK YOUR CAR

3-065 — PARK & LOCK YOUR CAR

Each ticket bears the following text:

This ticket licenses the holder to park one automobile in this area. PARK AS DIRECTED BY ATTENDANT. The management hereby declares itself not responsible for fire, theft, damage or loss of car or any article left in same, all of such risk being assumed by licensee. Only a rental of space license is granted hereby and no bailment is intended or granted. THIS LICENSE SHALL END AT MIDNIGHT OF THE DAY UPON WHICH THE LICENSE IS ISSUED.

Row 1: 1-449 | 2-401 | 2-344 | 2-962 | 1-564 | 1-192

Row 2: SOMEONE | 2-031 | 2-065 | 2-100 | 1-865 | 1-193

Row 3: 1-388 | 1-103 | 3-201 | 3-192 | 1-593 | GO

Row 4: 2-212 | 1-003 | 1-037 | 2-327 | 3-021 | 1-374

Row 5: 1-554 | 2-643 | ELSE | 2-153 | 1-941 | 1-023

Row 6: 1-681 | 1-372 | 2-047 | 1-443 | 1-223 | 3-454

Row 7: 3-006 | FIRST.

Each ticket reads:

PARK & LOCK YOUR CAR

This ticket licenses the holder to park one automobile in this area. *PARK AS DIRECTED BY ATTENDANT.* The management hereby declares itself not responsible for fire, theft, damage or loss of car or any article left in same, all of such risk being assumed by licensee. Only a rental of space license is granted hereby and no bailment is intended or granted. THIS LICENSE SHALL END AT MIDNIGHT OF THE DAY UPON WHICH THE LICENSE IS ISSUED.

TH1NK

4OR

YOUR:5E7F

Thought Police. He was the...
...adowy army, an underground netwo...
...hrow of the State. The Brother...

DOWN WITH BIG BROTHER
DOWN WITH BIG BROTHER
DOWN WITH BIG BROTHER
DOWN WITH BIG BROTHER
DOWN WITH BIG BROTHER

...particula...
...d act of openin...
...mpted to tear out...
...enterprise altogether...
...ouse he knew...

BROTHER

The Thought Police would ge...
...ll have commun...
...er the essential...
Thoughtcrime. It...

not by making yourself heard but by staying sane that...
carried on the human heritage. He went back to the ta...
dipped his pen, and wrote:

To the future or to the past, to a time when thoug...

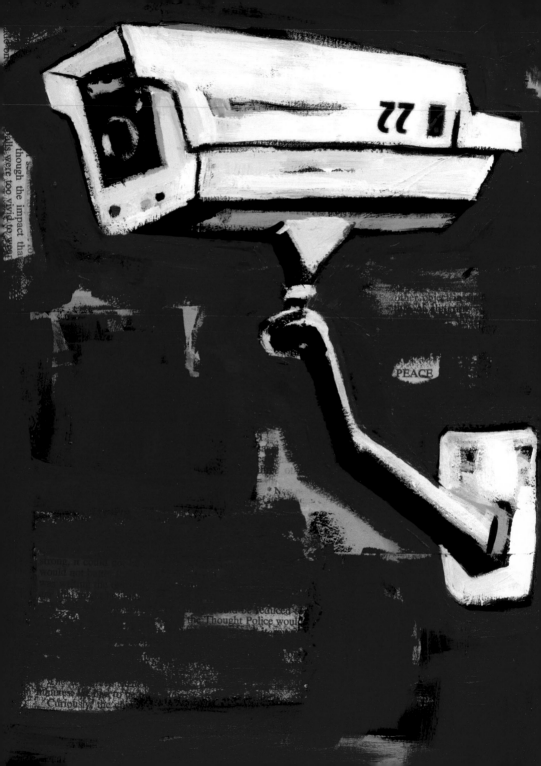

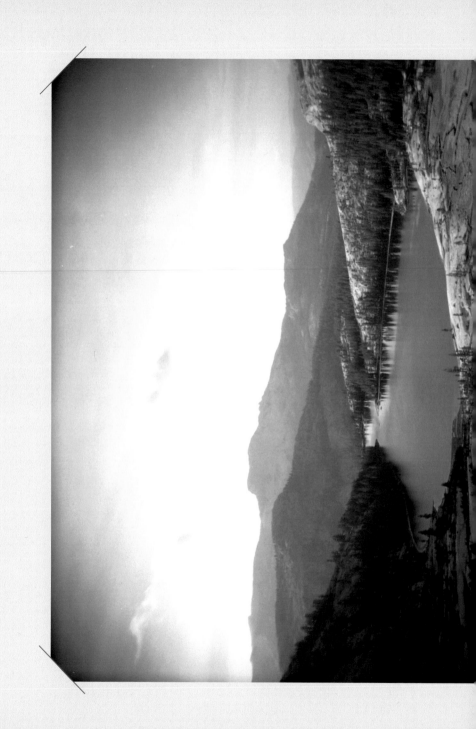

[fig. 78]

WALK BY THE OCEAN,

A RIVER,

OR A LAKE.

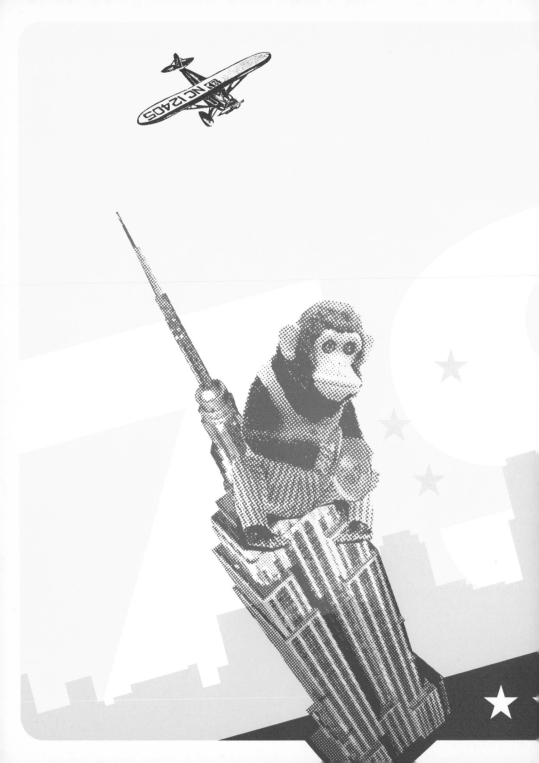

RECOGNIZE THAT ALL CREATURES
have the
right to life

81

DON'T HOLD A GRUDGE.

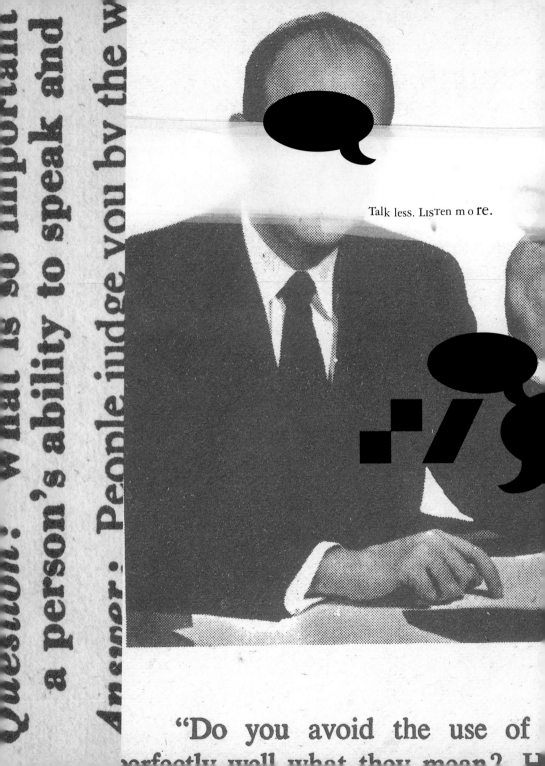

Question: What is so important a person's ability to speak and

Answer: People judge you by the w

Talk less. Listen more.

"Do you avoid the use of

83

ADOPT OR FOSTER **A WAITING CHILD.**

84 OPPOSE

that harm

echnologies jies

the environment

that harm

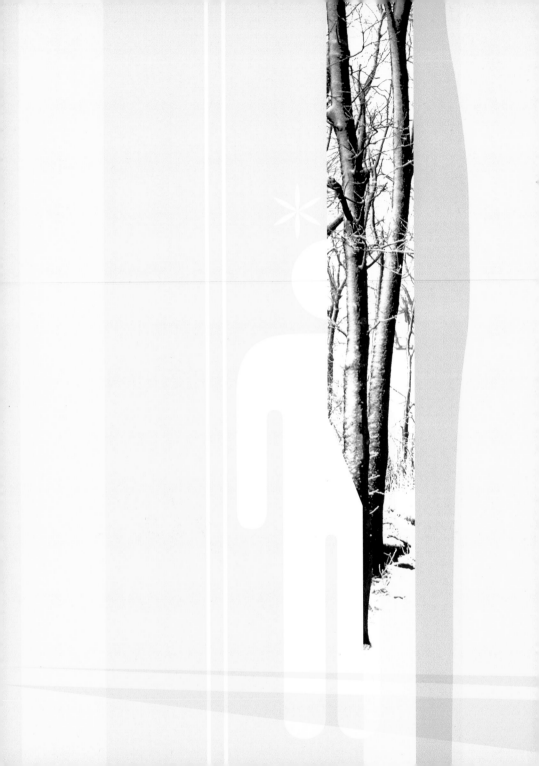

Lose an argument to a loved one.

Nov 2, 2003

Dear Dave,

Too much time has passed, and we
didn't part on good terms. Much of
this is my fault. I was angry, and I
blamed you for what happened. It
took me a long time to realize that
our friendship means too much to
me to leave it end like this. I
knew you didn't intend to hurt me,

or Jessica for that matter (she has ~~since~~ since left, and taken the cat with her). For what it's worth, I forgive you. I forgive you for everything. I sincerely hope you forgive me too..... I just want my friend back.

Love, Tracy

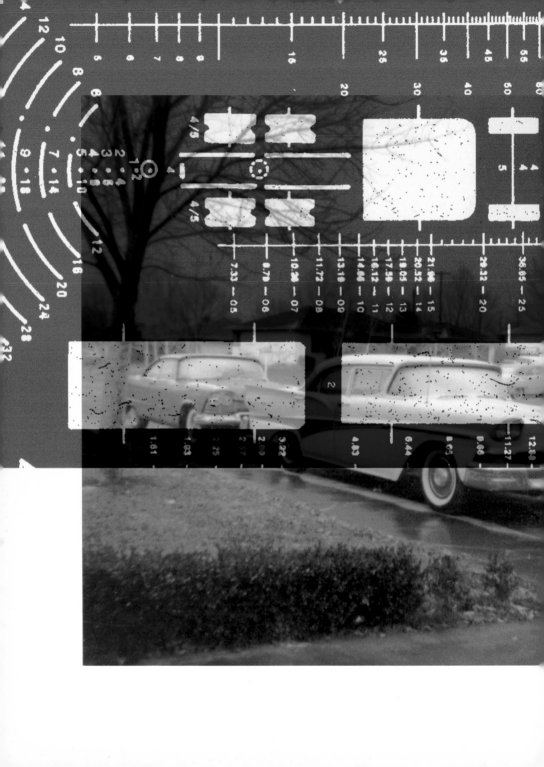

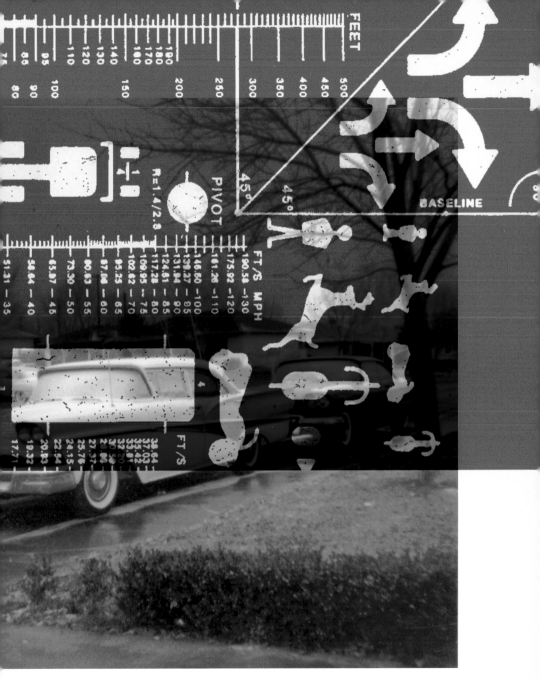

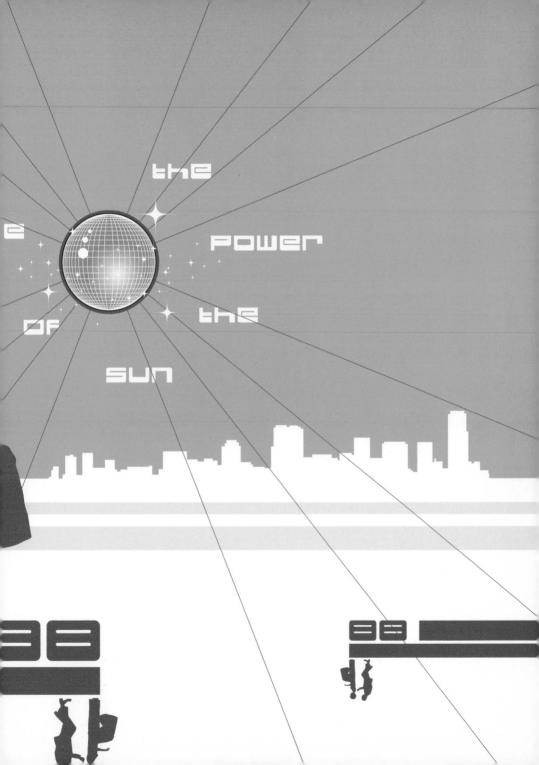

SPEAK OUT FOR
GLOBAL DISARMAMENT

ACKNOWLEDGED NUCLEAR
WEAPONS CAPABILITY

UNACKNOWLEDGED NUCLEAR
WEAPONS CAPABILITY

SEEKING NUCLEAR
WEAPONS CAPABILITY

089

SPEAK OUT FOR
GLOBAL DISARMAMENT

30,000 INTACT NUCLEAR WARHEADS
THROUGHOUT THE WORLD. 17,500
ARE CONSIDERED OPERATIONAL.

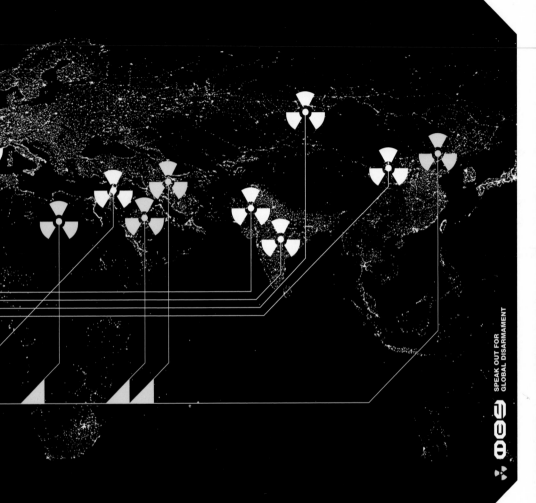

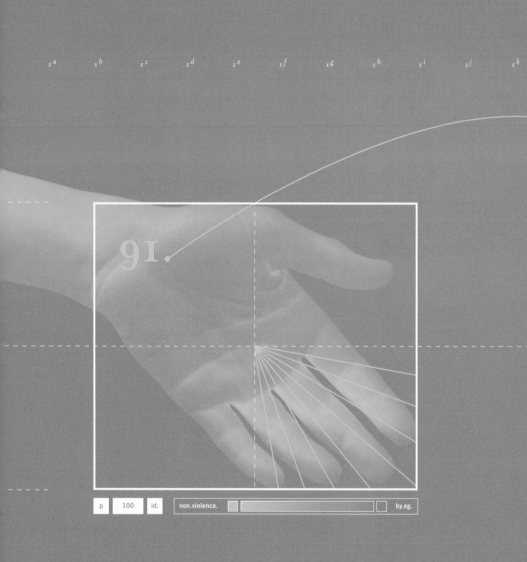

91.

x^a x^b x^c x^d x^e x^∫ x^g x^h x^i x^j x^k

p 100 id. non.violence. by.eg.

x^m x^n x^o x^p x^q x^r x^s x^t x^u

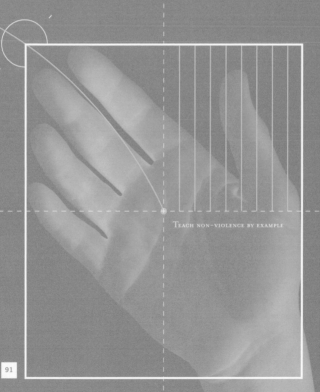

TEACH NON-VIOLENCE BY EXAMPLE

91

92
Ask Questions

93.

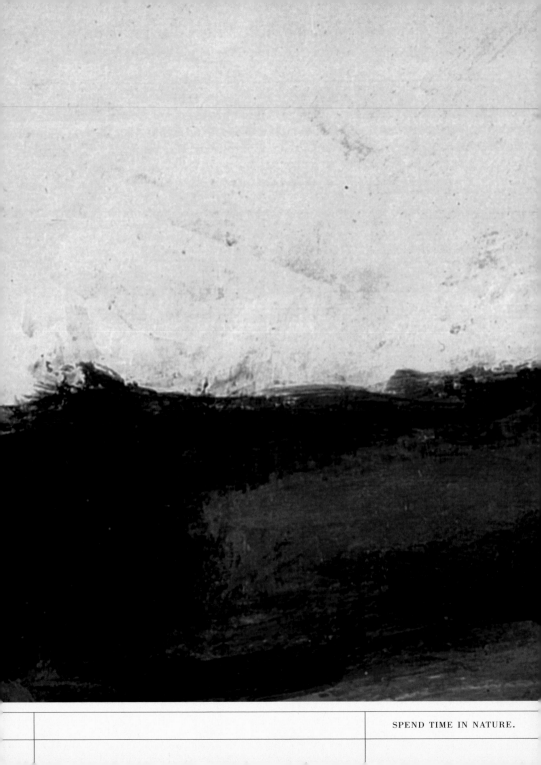

SPEND TIME IN NATURE.

094

BOYCOTT WAR TOYS

5.

THANKFUL

FOR THE MIRACLE OF LIFE.

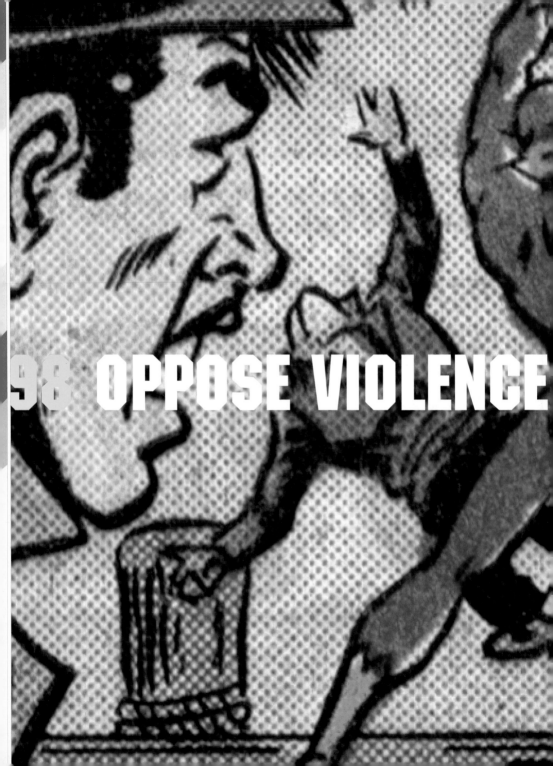

99::keep things in perspective

100

ACT

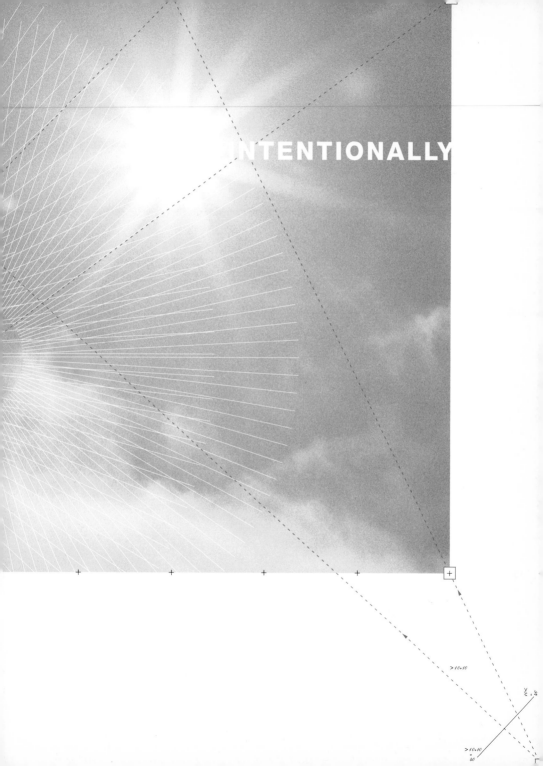

1. Be generous with your smiles.
2. Commit daily acts of kindness.
3. Recycle.
4. Walk in a forest.
5. Plant a tree.
6. Be outside.
7. Don't pollute.
8. Live simply.
9. Skip a meal each week.
10. Erase a border in your mind.
11. Teach peace to children.
12. Write a letter to your President.
13. Study the lives of peace heroes.
14. Demand honesty from your government.
15. Think about consequences.
16. Commit yourself to nonviolence.
17. Support nonviolent solutions to global problems.
18. Speak up for a healthy planet.
19. Demand reductions in military expenditures.
20. Be fair.
21. Be honest.
22. Consider the larger implications of what you do.
23. Sponsor a needy child abroad.
24. Recognize your unique potential.
25. Think of the we, not just the me.
26. Be less materialistic.
27. Be more loving.
28. Empower others to be themselves.
29. Oppose all weapons of mass destruction.
30. Prevent the abuse of power.
31. Work for an international ban on land mines.
32. Pray.
33. Listen to your heart.
34. Help the poor.
35. Fight against militarism.
36. Support the cause of women without power.
37. Help create a community peace park or garden.
38. Commemorate the International Day of Peace.
39. Advocate universal health care.
40. Stand up for justice, even it means personal inconvenience or suffering.
41. Oppose guns in the home.
42. Be aware of the rights of future generations.
43. Send a note of appreciation.
44. Join an action alert network.
45. Call your mom.
46. Laugh more.
47. Play with a child.
48. Support health, education and the arts.
49. Help educate the next generation to be responsible.
50. Accept personal responsibility for creating a better world.

| 51 | Sing. | 76 | Let someone else go first. |
|---|---|---|---|
| 52 | Write a poem. | 77 | Think for yourself. |
| 53 | Respond to words of peace. | 78 | Walk by the ocean, a river, or a lake. |
| 54 | Learn about a different culture. | 79 | Recognize that all creatures have the right to life. |
| 55 | Help someone. | | |
| 56 | Ask for forgiveness. | 80 | Respect the dignity of each person. |
| 57 | Contemplate a mountain. | 81 | Don't hold a grudge. |
| 58 | Clear your mind. | 82 | Talk less. Listen more. |
| 59 | Breathe deeply. | 83 | Adopt or foster a waiting child. |
| 60 | Sip tea. | 84 | Oppose technologies that harm the environment. |
| 61 | Express your views to government officials. | 85 | Lose an argument to a loved one. |
| 62 | Fight for the environment. | 86 | Forgive someone from your past. |
| 63 | Celebrate Earth Day. | 87 | Walk softly on the Earth. |
| 64 | Think like an astronaut. Appreciate that we have only one Earth. | 88 | Appreciate the power of the sun. |
| | | 89 | Speak out for global disarmament. |
| 65 | Be constructive. | 90 | Strive to understand the chain of events. |
| 66 | Volunteer time at an afterschool program. | 91 | Teach non-violence by example. |
| 67 | Purchase products that respect the earth's resources. | 92 | Ask questions. |
| 68 | Work in a garden. | 93 | Spend time in nature. |
| 69 | Change a potential enemy into a friend. | 94 | Boycott war toys. |
| 70 | Don't tolerate prejudice. | 95 | Be thankful for the miracle of life. |
| 71 | Share. | 96 | Seek reconciliation in your relationships. |
| 72 | Purchase products that support fair labor practices. | 97 | Help make a wish come true. |
| 73 | Be a voice for the voiceless. | 98 | Oppose violence in children's media. |
| 74 | Tell your friends how much they matter. | 99 | Keep things in perspective. |
| 75 | Say "I love you" more. | 100 | Act intentionally. |

THIS BOOK WAS PRINTED WITH 100% POST
CONSUMER RECYCLED FIBER, OXYGEN BLEACHED,
ELEMENTAL CHLORINE-FREE. BY CHOOSING THIS
ECO-FRIENDLY STOCK INSTEAD OF VIRGIN PAPER,
THE FOLLOWING SAVINGS TO OUR NATURAL
RESOURCES WERE REALIZED:

72 TREES

41,650 POUNDS OF WOOD

61,240 GALLONS OF WATER

6,494 POUNDS OF LANDFILL

12,598 POUNDS OF GREENHOUSE
GAS EMISSIONS

100,926 BTU OF ENERGY

The above information is based on 67,500 sheets of Save-A-Tree Matte PC 100,
87lb text, 25.5" x 38", 178M. Data research provided by Environmental Defense.

Printing: Hemlock Printers, Ltd., Vancouver, B.C., Canada. www.hemlock.com
Lithographed four process colors, deboss, smyth sewn and casebound. Hemlock
is committed to the use of environmentally responsible papers.

Paper: Save-A-Tree Matte PC 100, 87lb. text, 100% post consumer waste, oxygen
bleached, elemental chlorine free.